Photography

The Beginners Crash Course in DSLR Photography

by James Clark

© 2016 James Clark
All Rights Reserved

Table of Contents

Table of Contents

Introduction

Chapter 1 – Manual and Priority Modes

Chapter 2 – When and How to Adjust the Aperture, ISO, and Shutter Speed

Chapter 3 – Lighting and DSLR Settings

Chapter 4 – Macro Photography

Chapter 5 –Photography Equipment

Conclusion

Disclaimer

While all attempts have been made to verify the information provided in this book, the author does not assume any responsibility for errors, omissions, or contrary interpretations of the subject matter contained within. The information provided in this book is for educational and entertainment purposes only. The reader is responsible for his or her own actions and the author does not accept any responsibilities for any liabilities or damages, real or perceived, resulting from the use of this information.

Introduction

So you have been taking amazing pictures with your awesome smart phone camera and you have decided to take the next step and learn how to use a DSLR camera; easy right? Sure, if you recognize all of the buttons, settings, lenses, lighting techniques, aperture, and ISO operations that sweet DSLR camera is capable of using.

Don't freak out, it actually is easier than is sounds, there is even a setting on most DSLR cameras that will allow you to just "Point and Shoot", but I wouldn't recommend spending a large sum of money to point and shoot.

As you read through this book you will become more than familiar with the terminology associated with DSLR photography. You will learn every setting on that camera and how to use them. You will also learn how to change lenses and why you would want to change lenses.

Lighting, aperture, ISO, will all become second nature to you as you embark on a hobby that will keep you busy for eons; there is always something that needs to be photographed!

For many, the new micro cameras on smart phones have more than enough pixels to create a clear, printable picture, and they are content. For others, like you and me, the camera on the phone will not produce the content we are envisioning, so…on to the DSLR.

The DSLR can do everything a phone camera can do and WAY more. You knew it could do amazing things when you first picked up that DSLR and had a look at all of those settings!

Who knows, your newly learned talent may make you a few bucks too. There are many ways to make some cash with digital photography if you have a talent for it. The global market is full of people who craft and sell it; many of them need images of their items to sell online.

 Lighting and composition is important for these types of photos, if you practice, you may find a way to make a few bucks doing something you love.

If making money isn't part of your future, you may still end up the "family" photographer and you will have to bring your camera to each and every family function from now until the end of time. Ok, this may be a bit dramatic, but your skills will

be in demand, everyone will want to know how you learned to take such beautiful pictures.

This book covers everything you need to know, but it is not camera specific. All DSLR cameras have similar functions, and the language/terminology is the same for all DSLR cameras. Some cameras have more, some have less functions, and you will learn how to use all of them so regardless of the camera you have, you will learn to use it like a pro.

Some of the most popular DSLR cameras are produced by Cannon and Nikon. These two top many of the professional lists of top DSLR cameras, and they are always listed on the best photography hobby sites and magazines.

These two companies have been producing photography gear for decades, way before the first digital cameras appeared on the scene so they know a thing or two about taking really great pictures.

Now pull that awesome piece of picture taking equipment out of the bag, box, drawer, closet, where ever it is stashed, and let's get started. Each chapter is labeled so if you already have some skills, you can skip what you know and get to the stuff you need to know while the rest of us move at our own pace.

Chapter 1 – Manual and Priority Modes

All DSLR cameras have similar functions and settings. It really doesn't matter if you have a Canon or a Pentax, learning to use the manual settings will be the same. You may have to check out your camera to find the right buttons, switches, and settings, but they are there, trust me.

Manual settings allow you to decide how you want your picture to look. You will not be great at using these setting right out of the box, it takes a bit of practice to gain the skills.

It is worth taking the time to learn manual settings, these settings make the difference between taking a picture with your camera phone, and taking an awesome photograph with a technical skill and artistic flair.

Here is a list of some of the common settings on a DSLR camera:

- P (Program Mode)
- A or AV (Aperture Priority)

- S or Tv (Shutter Priority or Time Value)
- M (Manual Mode)
- ISO speed

Program Mode - On the dial of the DSLR camera you will find the letter P, this P stands for program mode. Program mode allows the camera to calculate aperture and shutter speed when an ISO is already set or selected. When the camera is in program mode the exposure is automatic but the other camera settings are manually set. In Full automatic mode, all of the settings are automatic.

A or AV – A stands for aperture priority, and AV stands for Aperture Value. This mode allows the aperture to be set manually while the shutter speed is set automatically for the best exposure with a set ISO sensitivity.

S or Tv – S stands for Shutter Priority and Tv stands for Time Value. With this setting the shutter speed is set manually and the aperture is set automatically by the camera for the best exposure with a set ISO sensitivity.

M – M stands for Manual Mode. In full manual mode, the shutter speed, aperture, and ISO are set manually by the photographer according their preferences.

ISO speed – ISO is used to set the light sensitivity of the image sensor. This setting determines how sensitive to light the camera will be.

All of the manual settings give you the ability to fine tune the exposure of the pictures you take. Unlike auto settings, the manual settings will allow you to control the exposure quality and artistic feel of your images. Tweaking the manual settings will provide you with the ability to take perfect photos in a number of lighting conditions.

In some situations, automatic settings will not give you the best exposure. When lighting is too bright, or too dark, or when there are too many shadows, or any other extreme in the ambient lighting, manual settings will give you a much better picture quality if you know how to use them. If you are interested photographing moving subjects, objects, or even

moving water, the manual settings on your camera will give the best results.

Nature photography is another situation where manual settings will provide a better picture. Nature is never predictable; animals, the weather, and dynamic landscapes are always in motion or change from one state to another.

Using automatic settings will not give you the versatility you need to produce the best picture your camera is capable of taking in every natural setting.

Actually, almost every situation can benefit from using manual settings as long as the photographer knows what to do. Using the manual settings requires knowledge of lighting and how it affects the subject, movement and how that can affect the image quality.

For example, taking a photo of a sporting event and capture the action can be done with automatic settings but that doesn't mean you have taken the best picture possible. With manual settings, the right lens and tripod if needed, you can capture the finest detail of an athlete as they perform a winning move.

It is the ability to combine shutter speed, aperture, and ISO that will give you the capability of taking the best possible picture, these three settings are known as the three pillars of photography.

In automatic mode, each setting is dependent on the others and the calculations are approximate; therefore, your image is approximate, not exactly as you want it. Manual removes the approximations of the camera and lets you choose the exact settings you want.

Professional photographers use manual settings because they are paid for their work. A wedding photographer must deliver quality images.

The bride does not want to hear, "the lighting was bad" or "you were moving too quickly, I couldn't get the shot", they want quality photos of their special day. Learning to use the manual settings on your DSLR camera has the potential to make every photo perfect.

Aperture Priority and Shutter Priority can deliver quality images too. Today's modern digital cameras are capable of calculating the perfect ratio between the set aperture and the shutter speed, and the set shutter speed and the aperture.

Many photographers use these settings without issue, but understanding full manual mode can tweak the results even more.

Aperture and shutter priority are not automatic mode, you must choose and set either the aperture or the shutter speed. Not all dslr cameras have a full manual mode but they do have fully automatic and aperture and shutter priority modes.

The manual to your camera will explain exactly what modes your camera is capable of. The manual will also explain the extent of your settings such as how high or low the aperture or shutter can be set.

Chapter 2 – When and How to Adjust the Aperture, ISO, and Shutter Speed

Aperture, ISO, and shutter speed work together to deliver quality exposure. If you use them correctly and in the right combinations, your photos will have great exposure. You can even learn to adjust these functions to create different effects in the raw image. A raw image is the photo file before it is tweaked with software.

A beautiful image that is in perfect focus cannot be replicated with software. An image can be cleaned up and "fixed", but it cannot be rendered perfect if the original raw file is not perfect.

Of course some may say this is not accurate, but in reality, photo software is designed to fix flaws, sharpen, remove noise, and in some cases blur; but the software is not magic, the closer the original image is to perfection, the better the software will work.

Different situations call for varying combinations of aperture, ISO, and shutter speed. Each setting is specific and when used in combination, any situation has the potential for a beautiful photo. The following is an explanation of what each setting does, including the aperture priority and shutter priority modes.

Aperture: Aperture is understood as a number value and preceded by the letter f. f/2, f/6, f/11, are all aperture settings. Photographers use the aperture to bring the focus to the front, back, or entire image. The aperture can blur the background and focus on area closest to the lens or focus on the background and blur the area closest to the lens. This is achieved by controlling the amount of light allowed to hit the image sensor.

ISO: ISO is the image sensors sensitivity to light. The normal range for ISO is from about 200 to 1600, your camera could have a range lower or higher. The lower the number the more light the image sensor will require, the higher the number, the less light the image sensor will require to produce a quality exposure.

Shutter Speed: The shutter speed can blur motion or freeze action depending on the setting. The shutter speed is the exposure time; it controls how long or short a shutter stays in the open priority. When the shutter button is pressed, the shutter opens and closes, the length of time it takes to open and close is known as the shutter speed.

A quick shutter speed will freeze action and a slow shutter speed will blur action/motion. Shutter speed is measured in divisions of seconds; $1/10^{th}$, $1/100^{th}$, $1/1000^{th}$. $1/10^{th}$ or one tenth of a second is slower than $1/1000^{th}$ or one one thousandth of a second.

A range of exposure differences can be achieved by adjusting all three of these settings. Learning how these settings work together and what they can produce will enhance your images.

These settings will allow you to take pictures of something as quick as a lightening strike, or enhance an image of a flowing river by blurring the water and bringing the rest of the photo into focus.

Now that you know how they work, it is time to learn how to choose and when to choose different settings.

As you practice taking pictures using different combinations pay attention to the results and re-take the same image with different settings. Here are some average settings for taking a photo of a quick moving subject in natural light.

A Bird in Flight – A bird in flight moves very quickly, a fast moving subject like a bird requires a quick shutter speed to freeze the action. For a subject as fast as a bird, a shutter speed of 1/1000 would be needed to freeze the action.

If you wanted that same bird to be in focus while blurring the background, you would adjust the aperture to a low f number like f/4

If the lighting for this image was a cloudy or partly cloudy day, you would opt for an elevated ISO number, the number would depend on how cloudy, and how much natural light was available. The higher the number, the less light the image sensor will need to produce a quality exposure/image.

Aperture and Shutter Priority – When using the aperture or shutter priority modes use the settings for aperture or shutter listed above. Practice using the shutter priority mode

and the aperture priority modes, they can be very helpful in different situations such as action shots and low light.

Aperture priority will allow you to set the aperture f number and the camera will automatically set the shutter speed, the shutter priority mode will allow you to set the shutter speed and the camera will automatically set the aperture number.

The only way you will become proficient at producing quality images is to practice with the different settings. Decide what you need, more light? Less light? Freeze the action? Blur the background? Then try out the manual settings and the priority settings. Once you see the results you can adjust and learn from there.

Experimenting and practicing is free with a dslr, you are not wasting money on film or developing. The time you spend practicing and experimenting with the settings will pay off. The rules for when and how remain the same, how you combine them to affect your exposure can only be perfected through practice.

Chapter 3 – Lighting and DSLR Settings

Light and the amount, lack of, and priority, will help you decide which manual settings you need to make in order to take a good picture. There are simple explanations for how to make settings for your light situation, but you can also adjust the lighting.

How the light falls on your subject will create shadows and highlights, adjusting the lighting can change these shadows and highlights so they enhance your photos.

Taking a picture in the shade requires different settings than a taking a picture in bright light. Artificial light is different than natural sunlight, and a flash is different from both. This chapter will describe the different lighting conditions and the best settings for each.

Manual Mode Settings

Aperture Settings – For sunlight use a high aperture setting, start at around f/12 and move up from there until you find the

right setting for your shot. Sunny 16 is usually the rule for shooting in sunlight, but there are variations in the brightness; starting at f/12 and moving up will help you learn what is bright, and what is not bright enough.

When shooting a subject in the shade or on a cloudy day start with an f/12 and move down until you find the right setting for your shot. When shooting indoors with no natural light begin at f/6 and move up if the light is bright and down if the light is low.

ISO Settings – For sunlight or any other lighting situation begin with an ISO of 100, you can move up or down to adjust for the amount of light you are shooting in; remember low ISO for bright light, higher ISO for lower light.

Shutter Speed Settings – Your shutter speed will depend on the subject matter, for action to freeze use a high shutter speed, to blur motion use a lower shutter speed.

Aperture Priority – If you choose to use the aperture priority set it to f/16 and the camera will adjust the other settings for a quality image. If you are not happy with the result, work with the f number, move up or down until you are satisfied.

Shutter Priority – If you choose to use the shutter priority set it for 1/125 and let the camera adjust the rest of the settings. If you are not happy with the result, work with the shutter setting by moving up or down until you are satisfied with the result.

If you decide to use a flash, reflectors, or something for shade, your settings will be different. Practice with the lighting equipment you want to use, begin with average settings in manual and move up or down until you are comfortable with each piece of equipment and the settings for using it in different situations.

The best way to learn is to practice with your equipment and adjust for your preferences with these settings a starting point. As long as you understand what you are accomplishing by moving each setting up or down, higher or lower, you will

eventually get a feel for how to get what you want in your photographs.

Chapter 4 – Macro Photography

Macro photography is all about taking photographs of tiny things and filling up the frame with the image. Macro photography of insects is done by using a macro lens, a tripod, a remote trigger, or the timer on the camera. This type of photography delivers detailed images of creatures as small as insects in crisp focus.

When shooting images of an insect using a macro lens it can be difficult to keep the camera still enough to eliminate camera shake. Using a tripod is one way to lessen camera shake. Using a remote trigger or the timer and a tripod can eliminate it all together, leaving you with a clear, crisp, detailed image of that little bugger.

Using a tripod and trigger will keep your hands from shaking the camera. When focusing on fine detail, any movement, no matter how slight, will disturb the image. Using a trigger and tripod is also a good way to keep from spooking your subject!

If the insect you are about to photograph is dark colored, a light colored background will make the bug stand out.

One way to get a light colored background is to blur the background so it blends together creating a backdrop for you subject. To do this, lower the f number, an f number of f/2.8 will blur the background and focus on the insect.

A light colored subject will stand out more on a dark background. One technique to achieve a dark background is to use a fill-light on a well-lit subject, this will darken the background and focus to the subject. Another way to separate the insect from the background is to place a piece of paper or cloth behind it; an even colored background will put focus on the insect.

The settings you use for your macro photography follow the same rules already explained for using the manual or aperture/shutter priorities. The difference is in the lens and the equipment.

Once you set up your equipment, try out different combinations of aperture, shutter speed, and ISO as you have for your other photography practice. Experimenting is the best way to hone your skills, the rules remain the same but how you utilize them will make all the difference.

When taking nature pictures such as macro's of insects, the natural lighting is important. Early in the morning or just before dusk provides the best lighting conditions.

Mid-day sun can be difficult to work with even if you put the sun to your back because you are using a trigger you are not exactly blocking the sunlight with your body. Choose the time of day as carefully as you choose your settings.

Chapter 5 –Photography Equipment

Now that you have an idea on how to use the settings on your camera you may want to start looking into photography equipment that can make your hobby easier and more enjoyable. There are pieces of equipment for just about every situation you can imagine. Some photography equipment is not a necessity unless you plan to be a professional, but there is equipment that is useful for beginners.

If you are a beginner you do not want to spend a lot of money before you need to. Purchasing expensive equipment before you learn how to use the camera effectively is a waste of money. You will acquire these items as you grow, you will realize what you need when the time comes.

The most important equipment you will need as a beginner is a good dslr camera, a sturdy case, a tripod and ball head, and a Speedlight. The rest will get added as you need them. You will not need reflectors until you know exactly what you want out of your lighting situation; and you won't know that until you can use the settings on your camera effectively.

Lenses are the most expensive equipment you will buy besides the camera. Lenses have many different uses but you will not need them right away. You will probably be better off purchasing a camera kit that comes with a few accessories and a lens or two.

A kit will provide you with some equipment to learn on and keep the expense low. Once you are proficient, you will want more control and have a better idea of what type of lenses you want.

Filters are fun and can make many jobs easier but you will want some experience with adjusting the settings before you begin using filters. Once you are good at using your settings, adding a few filters will broaden your creative spectrum and help you adjust and fine tune the settings you already know how to use.

If you still want to have some lens filters, look for a set or kit that comes with a few of the most common ones. This way you will get a feel for how they affect exposure without spending too much money. Many photographers don't use them at all, and other swear by them.

A Tripod – You probably already know what this is but just in case…a tripod is a stand that holds the camera for you. This stand will keep the camera still and eliminate camera shake. It is also used with a trigger or timer for macro photography or for taking a group picture with a timer or trigger so you can get in the photo too!

A Midi Ball Head or Ball Head – This is the piece of equipment that connects your camera to the tripod. The ball head allows you to adjust the angle and swivel of the camera and lock it into place, you can also make sure the camera is level. A quick connect plate will make it quick and easy to connect your camera to the ball head.

Reflectors – Reflectors are used to reflect light into areas of the frame where you want to diffuse shadows or add some fill light. They can be used to reflect light up or down, allowing you to control how the light is positioned on the subject or object you are photographing.

Umbrella's and Shades – Umbrellas and shades are used to deflect light and control the amount of light on the subject or object you are photographing.

Memory Cards – There are several types of memory cards used in digital photography. SD and Compact Flash are the most popular and they are available in a range of memory sizes. It is always a good idea to keep a few of these in your camera bag, you never know when you might need extra storage. Make sure you check your camera and find out what you need for your particular model.

Camera Bags – Camera bags are important; they protect that expensive camera from damage. There are many different kinds of bags available, some have special spaces for holding your small items like memory cards and batteries. Larger bags have foam spacers you can use to make spaces for extra lens and partitions to keep your camera from bumping up against your lens. They even have straps for holding your tripod.

Photo Printers – Photo printers and photo paper are like having a developing lab in your home. You can go and have your images printed from your memory card from a kiosk or on line at your favorite photo place like snap fish, but a printer purchase will pay for itself in the long run. A good photo printer and good photo paper will provide the same quality as a kiosk at your local drug store or online photo store.

Cables – The right cable will make life a whole lot easier!

Your camera came with cables to connect your camera to printers and computers. Nothing is worse than taking some awesome photos and not having a cable to get them onto the computer screen. Purchase an extra cable so you will have one at home and one in your camera bag, it is worth the peace of mind.

Speedlight – A Speedlight will help you eliminate grainy photos caused by low light situations. It is also useful for providing quality light in indoor areas where lighting is causing unnatural skin tones or yellow/greenish tones. The light produced by a Speedlight or off camera light will provide a better quality light for better color tones.

Lenses – The three most common lenses are wide angle, telephoto and macro. A wide angle lens is best for getting more area into your shot, a telescopic lens will allow you to bring distant subjects closer, and a macro is for taking close up shots.

The focal length of a lens is measured in millimeters, the shorter focal lengths are wide angle lenses, longer focal lengths are telephoto lenses. Your camera has a specific lens mount and only a lens made for your camera will fit. Some companies make lenses for multiple camera brands and only ones for your make and model will fit your camera.

Lens Filters – There are many types of lens filters for dslr cameras and they all have their specific uses. A UV, clear, haze filter is used for any photography situation, the main purpose of this filter is to protect the lens from dirt, dust, and debris.

A polarizing filter is used for any type of photography situation where you want to filter out polarized light to add contrast and keep colors true. A close up filter or diopter is used for macro photography; it allows for closer focus.

A warming, color, or cooling filter adjusts the white balance by correcting colors; some filter out a specific color altogether. Other types of filters for specific situations such as landscape lighting or flash correction and effect lenses that add effects are available depending on your camera and the lenses available.

Conclusion

Wow you did great! You are on your way to becoming a better "Photographer" and your skills are ready to get busy. So now that you can sling a DSLR camera with the best of them, what are you going to do? If you have children, you are going to take pictures of them, and if you do, you will need a bigger hard drive or some extra cloud storage.

Make sure you pack your camera and lens for trips, even if you are only going to a local park. You will be amazed at all of the photograph opportunities that will pop up. Squirrels will become adorable subjects for trying out those zoom lens and your macro lens are perfect for getting too close for comfort with insects.

Remember to practice and experiment, it is easy to delete any awful pictures you take. The more you practice and experiment in different lighting conditions, with combinations of settings, and different pieces of equipment, the better you will become.

You can use just about anything as a subject for practice, your dog, a doll, and even the cat, if you can get her to stay for the experiment.

If animals and insects are not your cup of tea, any tree, building, garden, or beach, will make perfect still images for framing. The best part is you can just print out your images for framing and display with nothing more than a good photo printer…gone are the days of darkroom developing.

Enjoy your new skills and make some beautiful memories!

www.ingramcontent.com/pod-product-compliance
Lightning Source LLC
Chambersburg PA
CBHW070425190526
45169CB00003B/1419